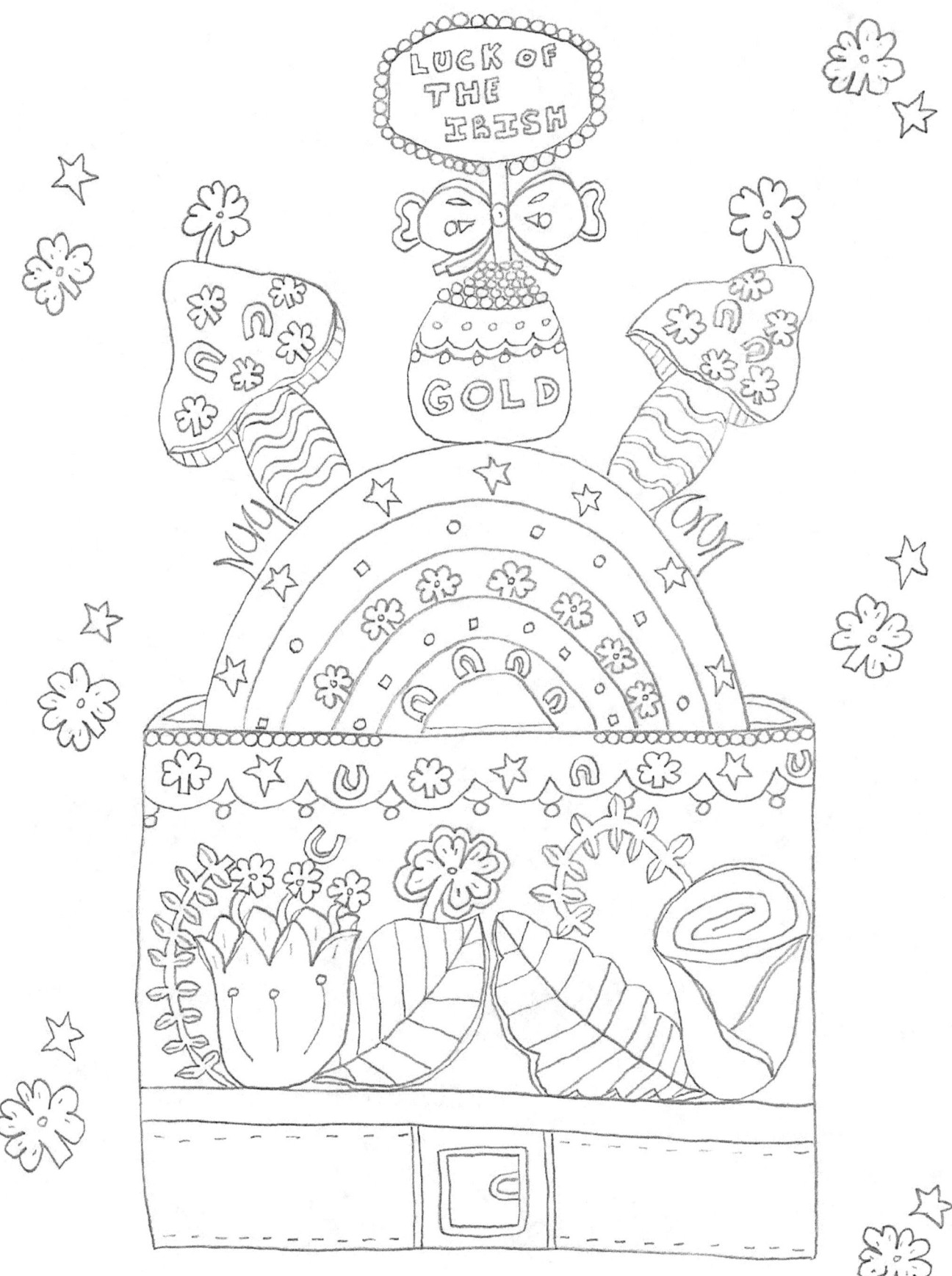

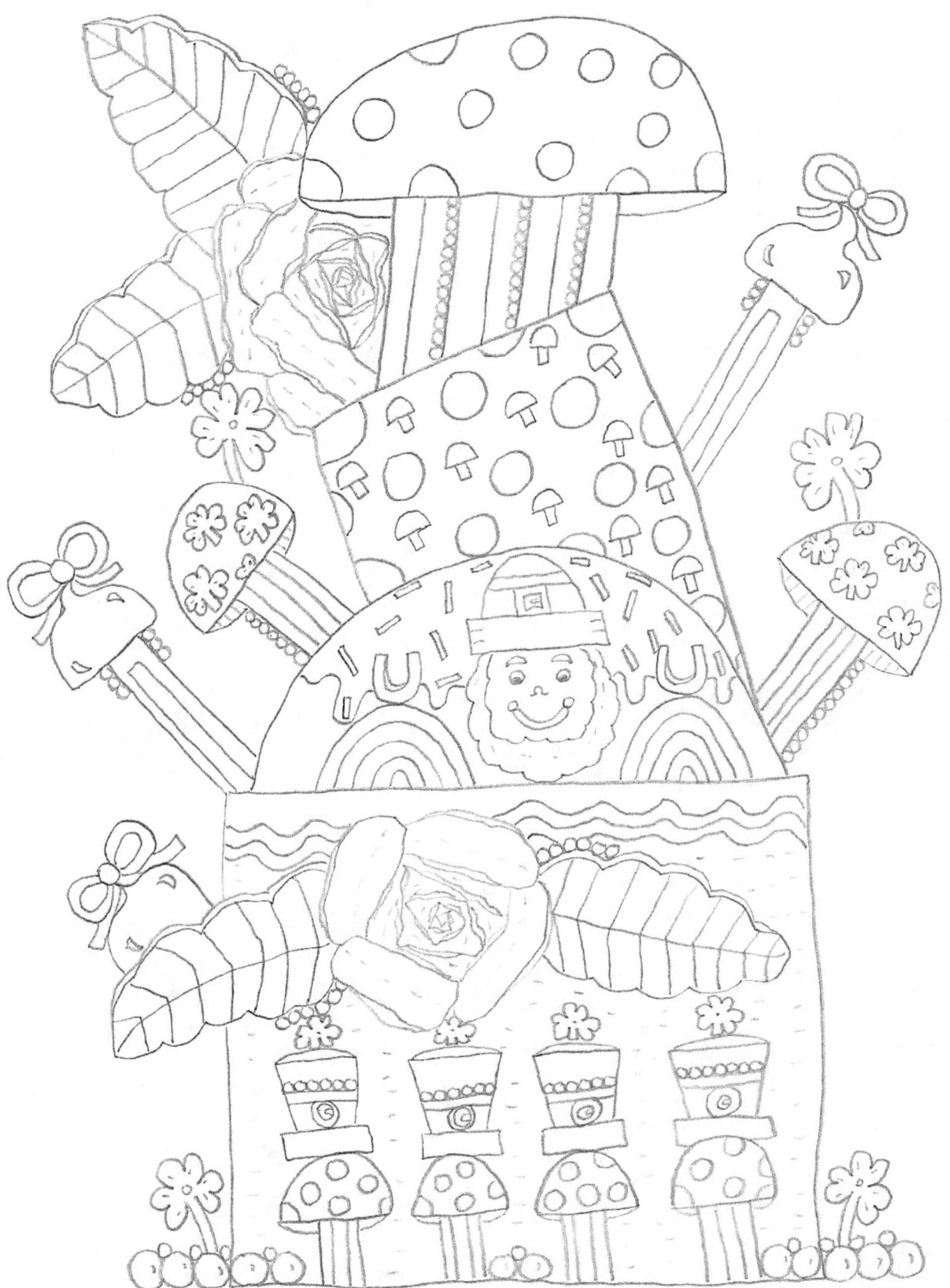

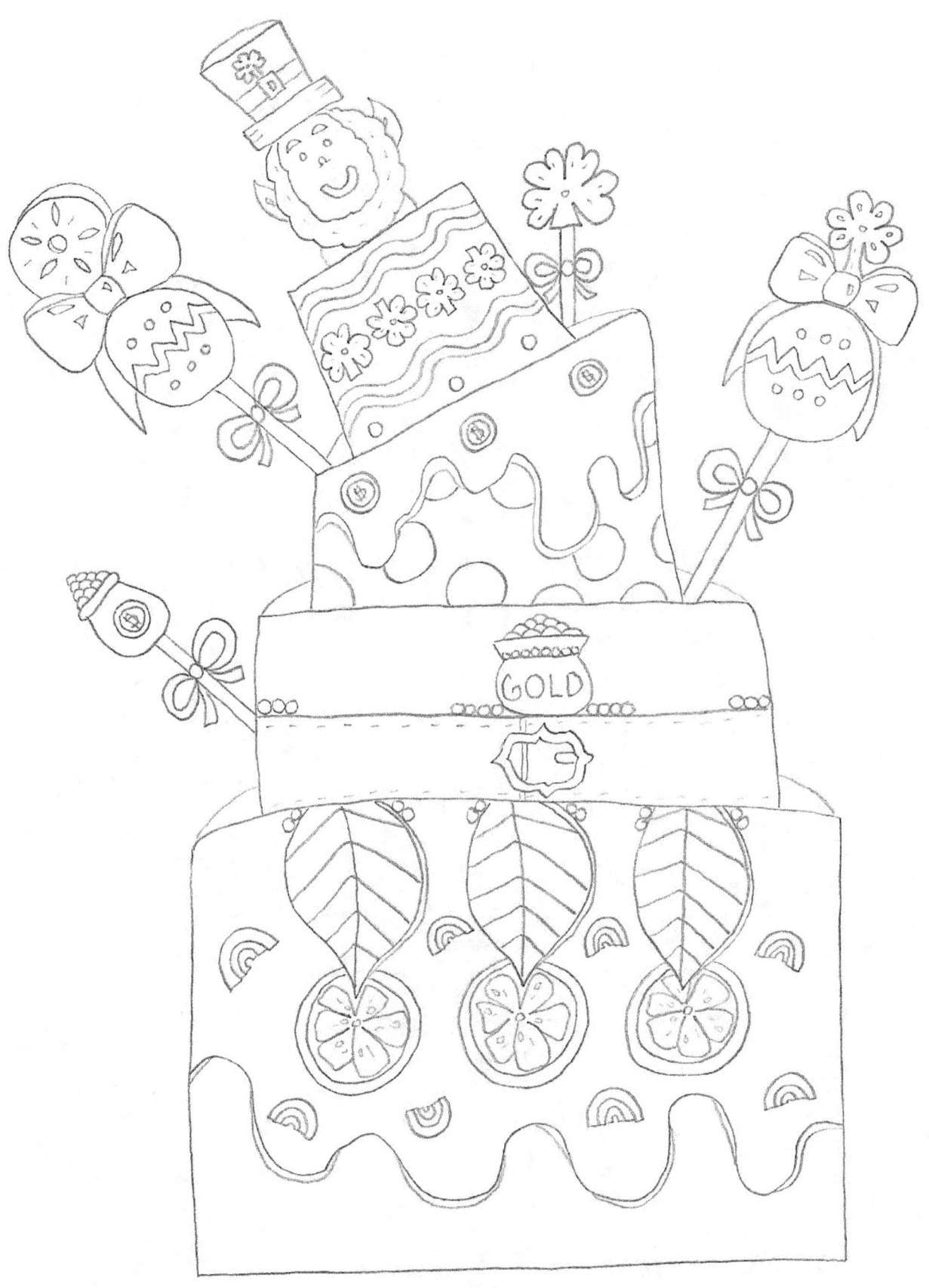

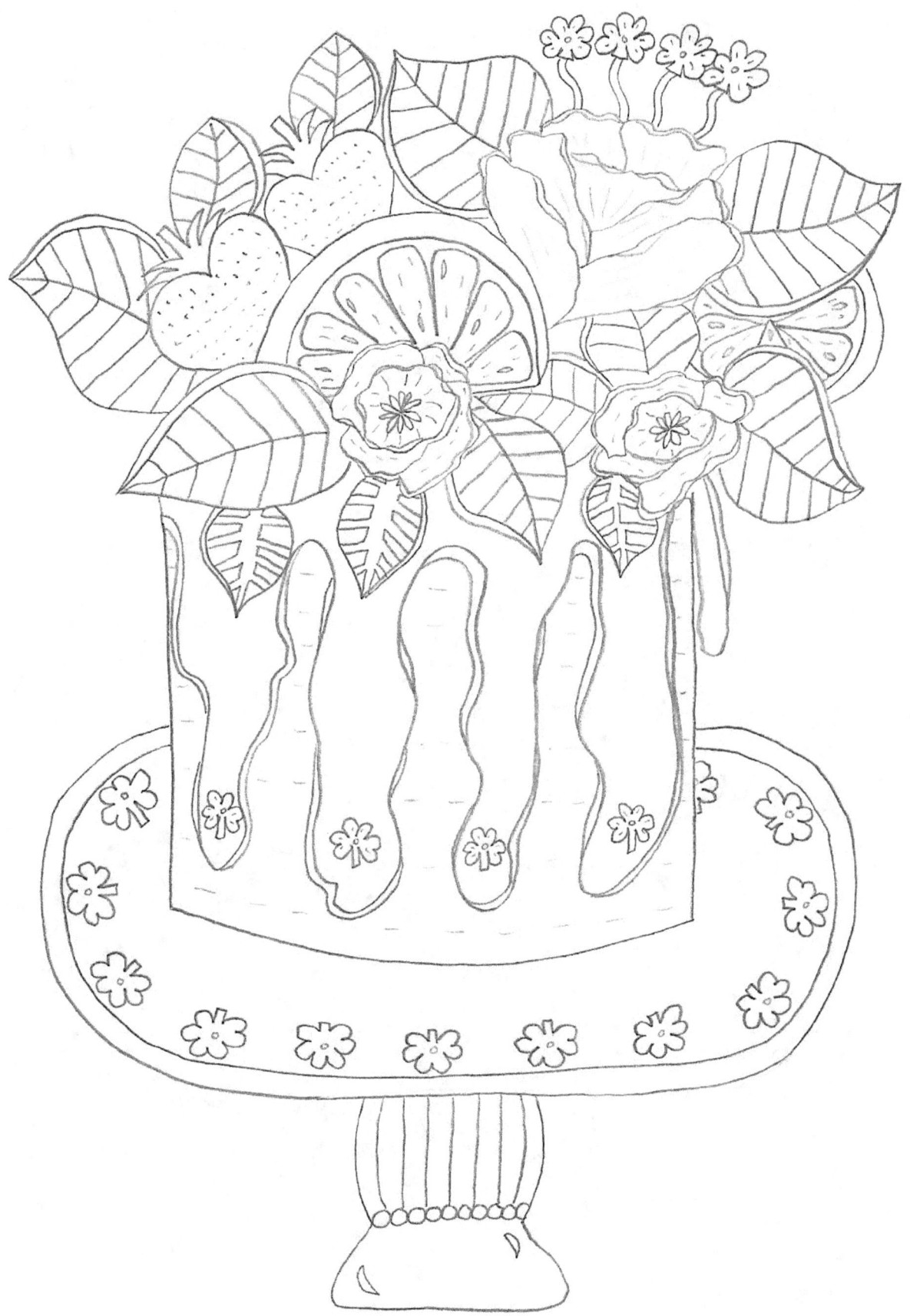

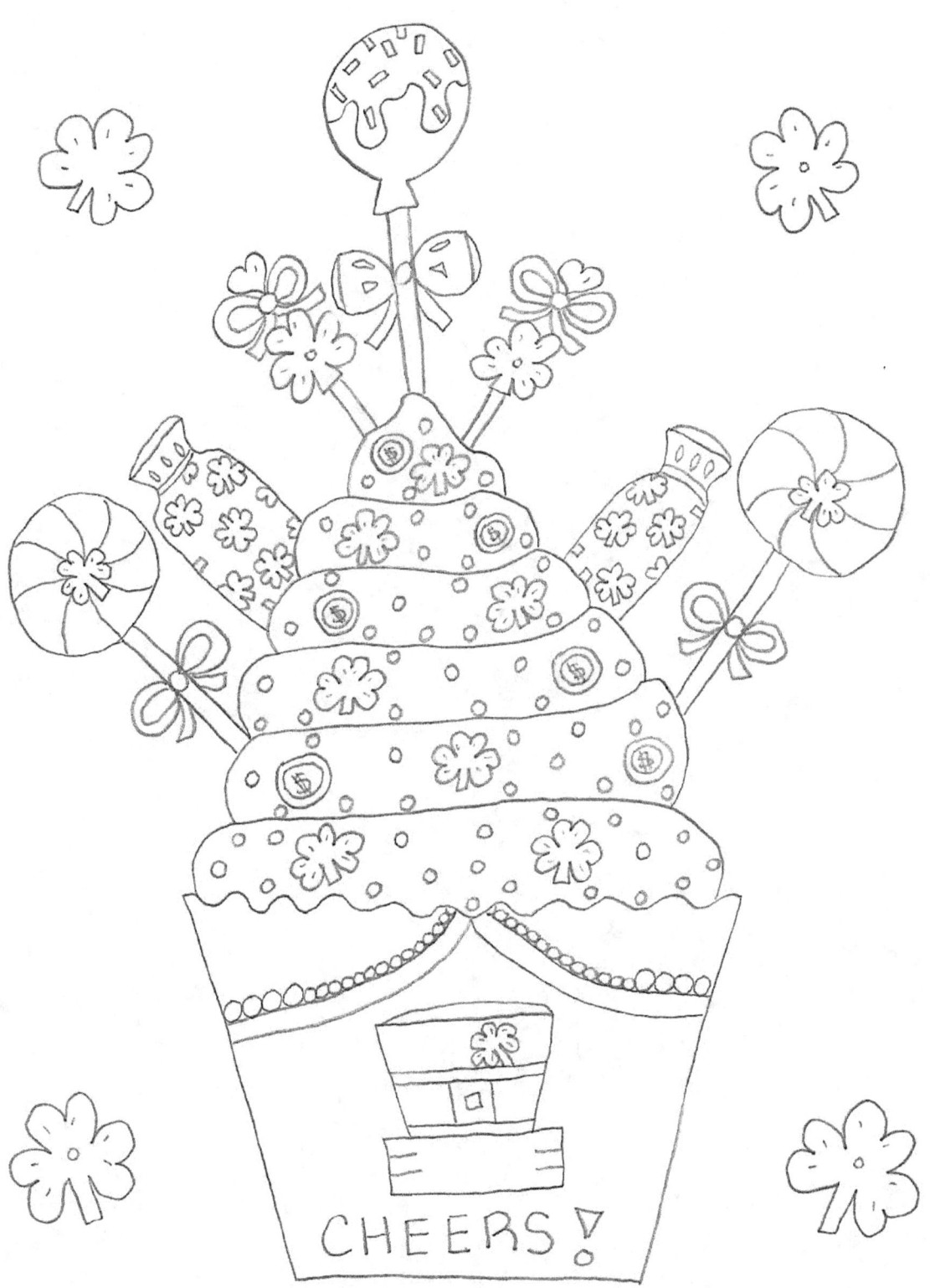

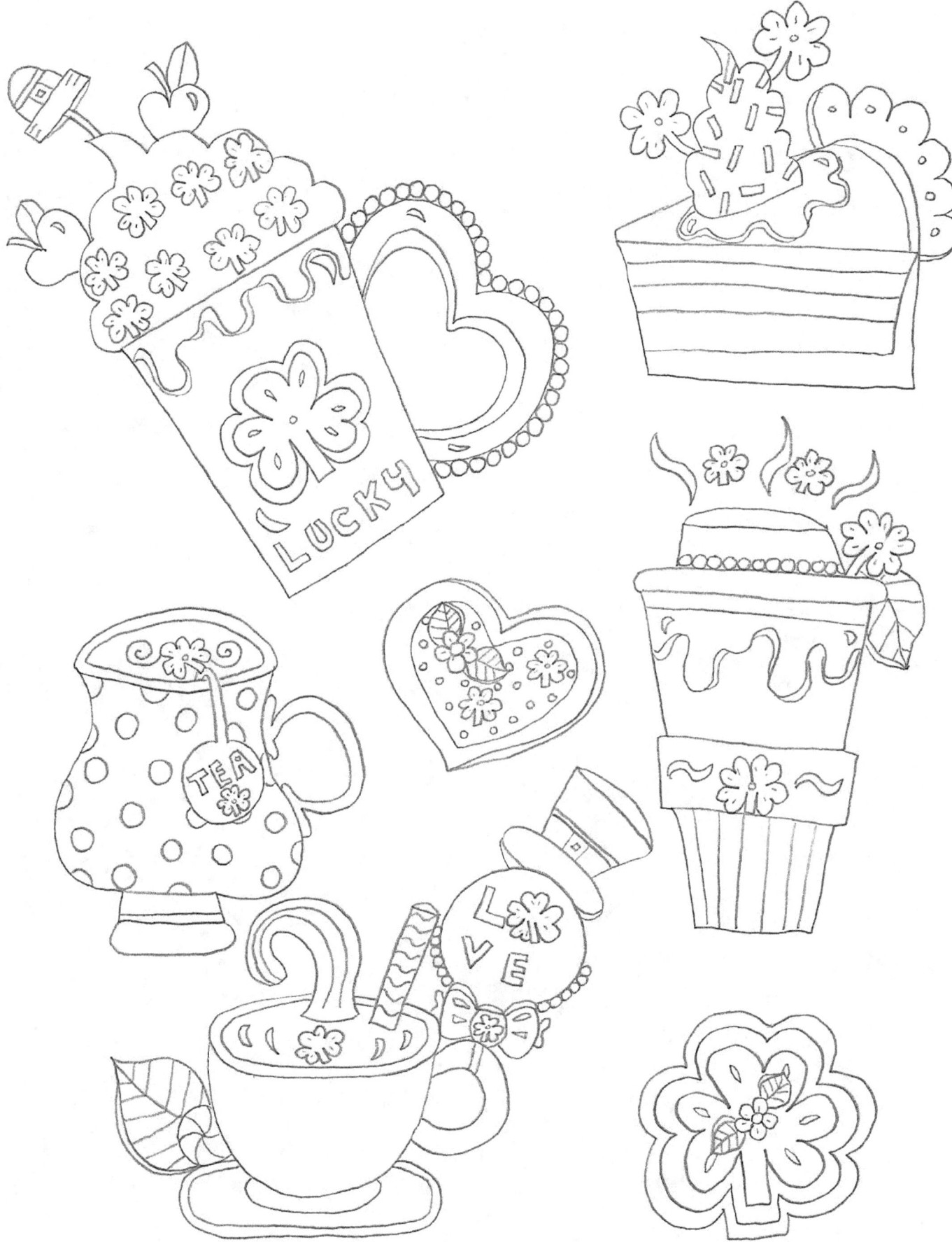

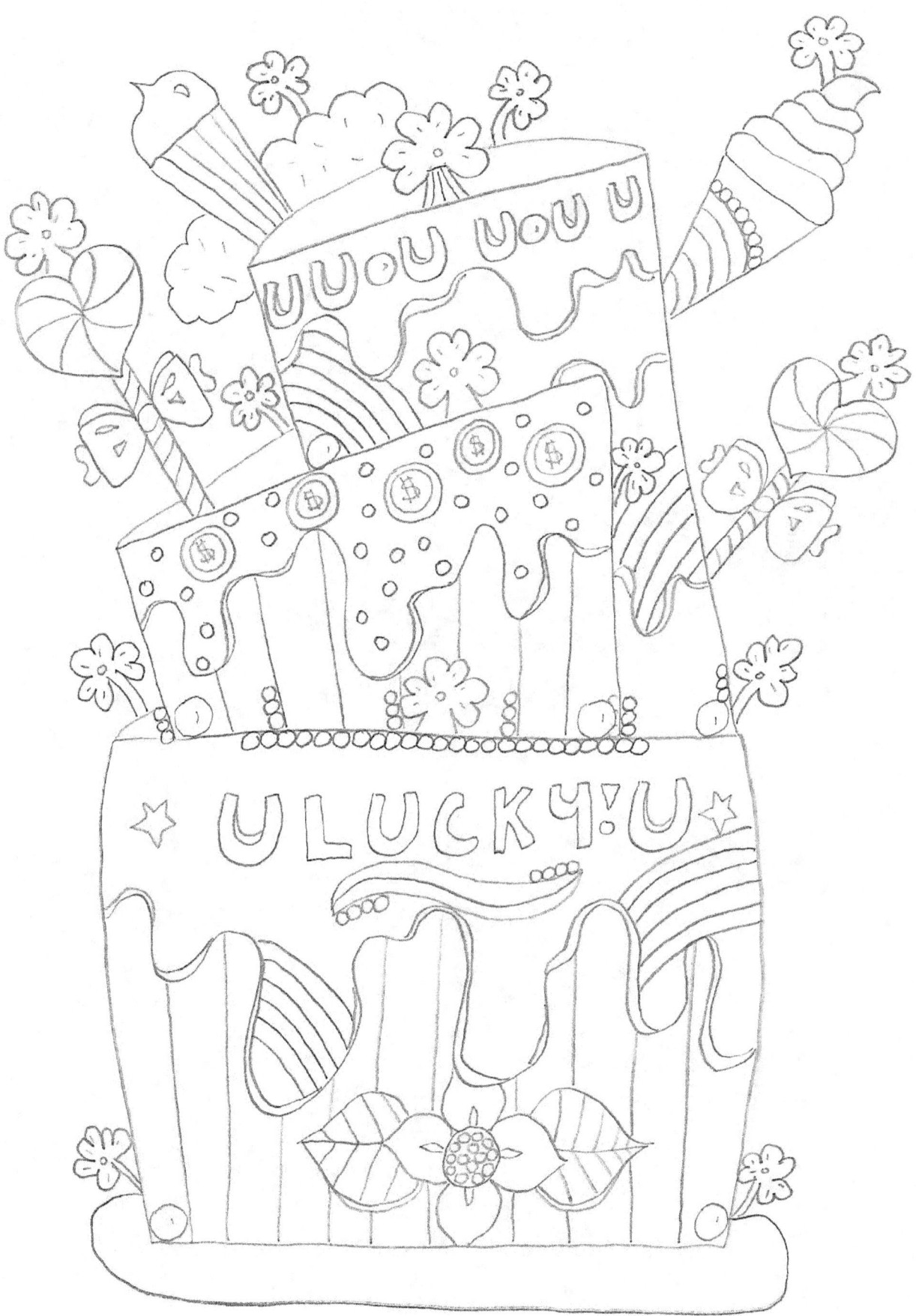

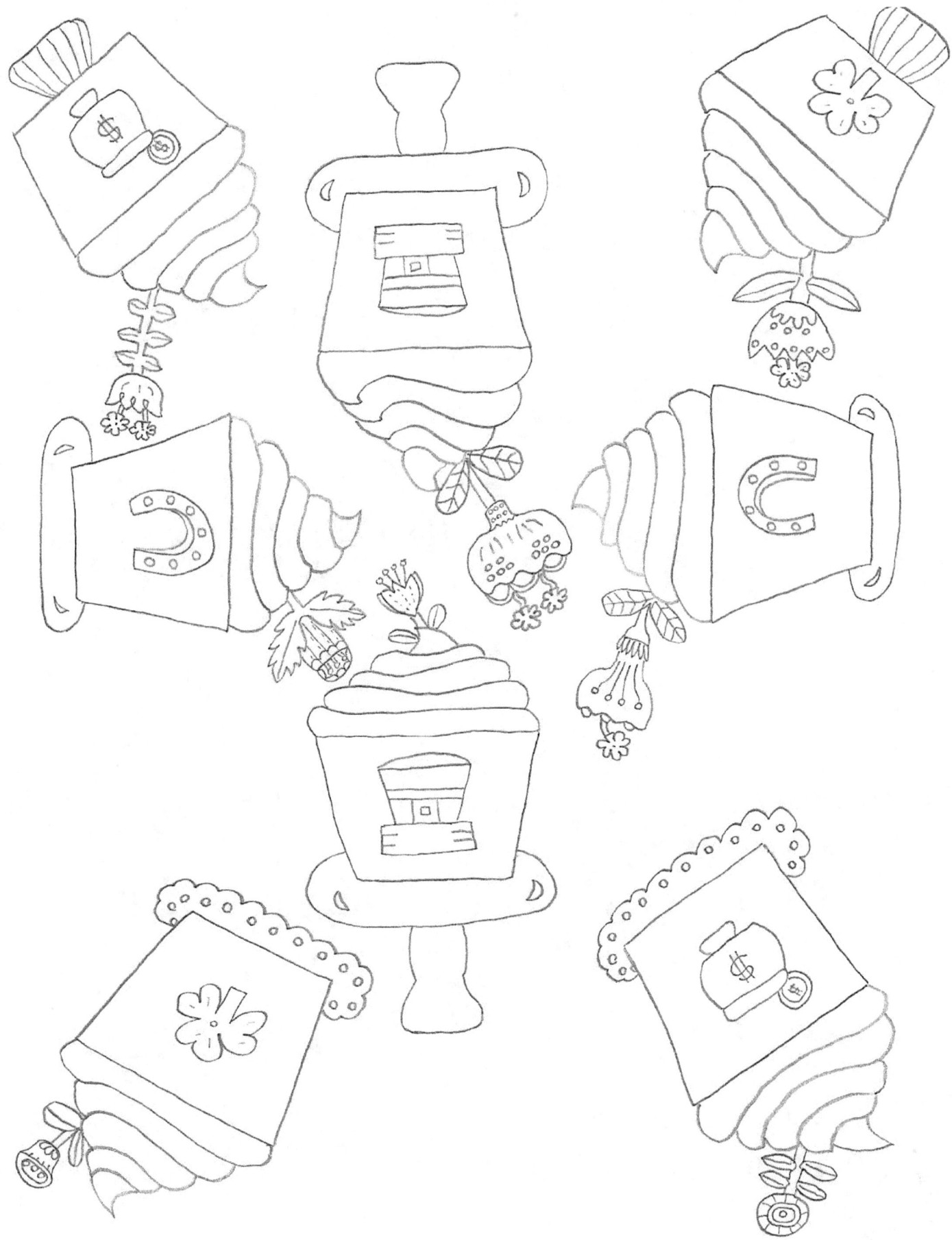

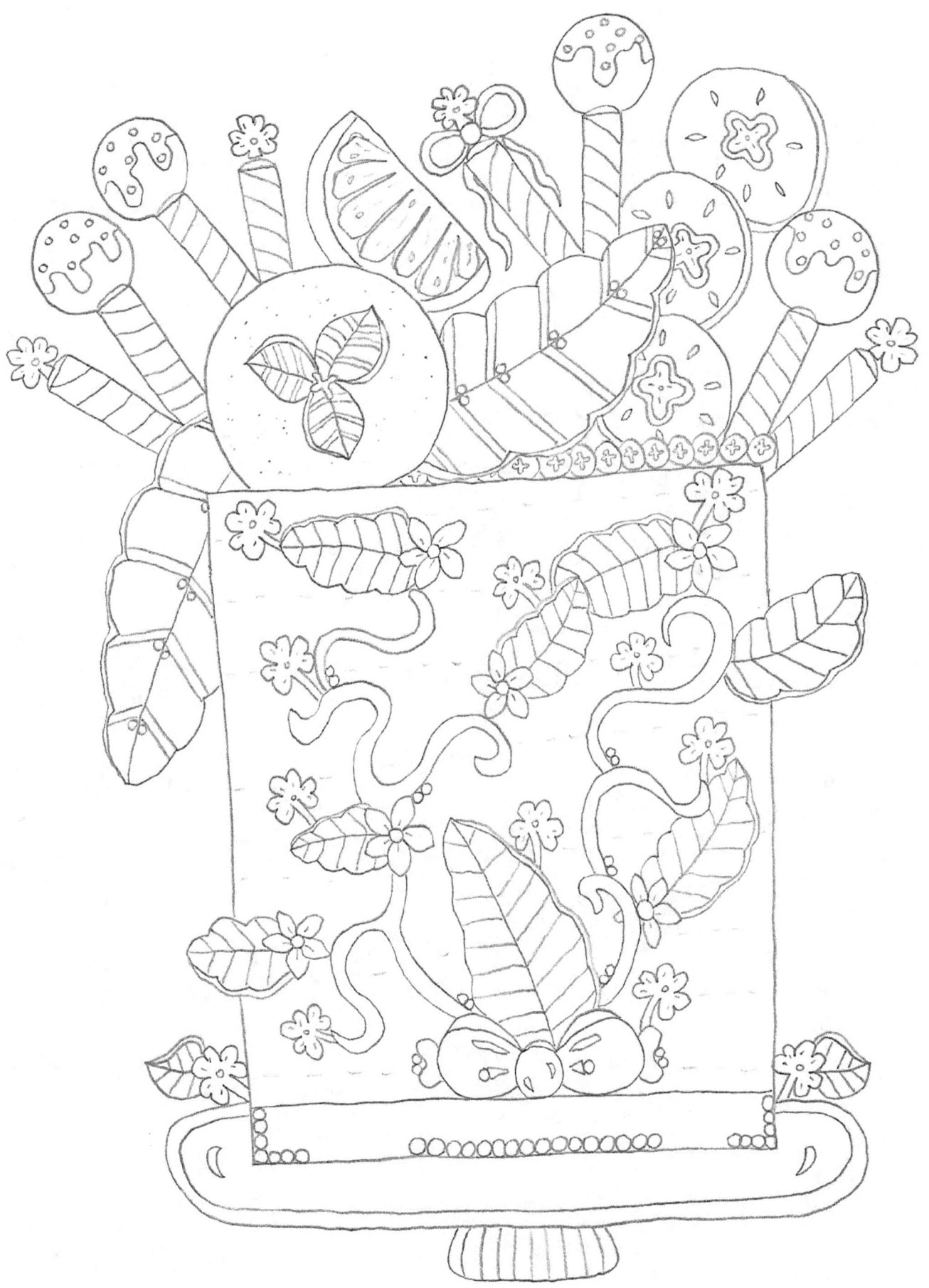

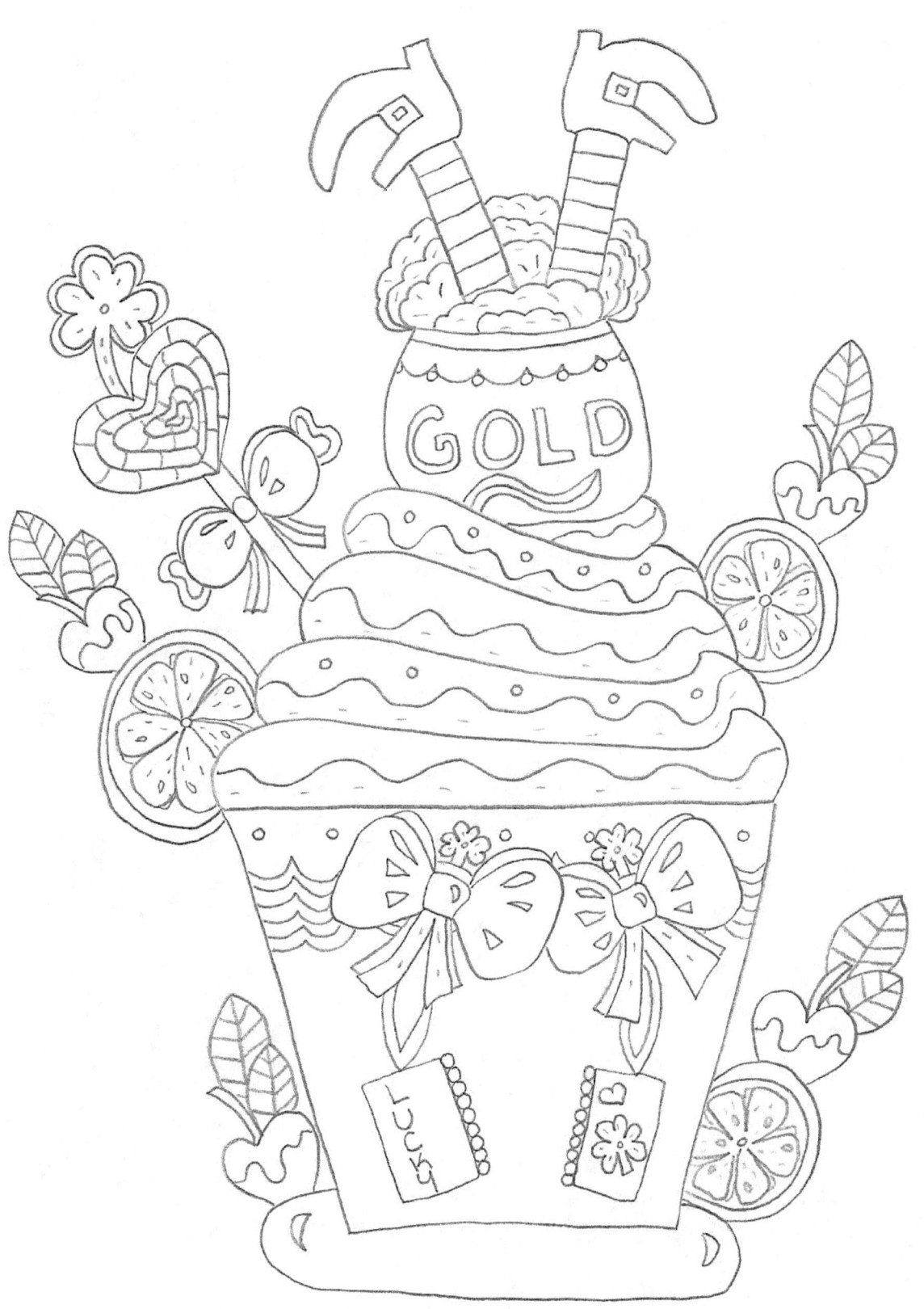

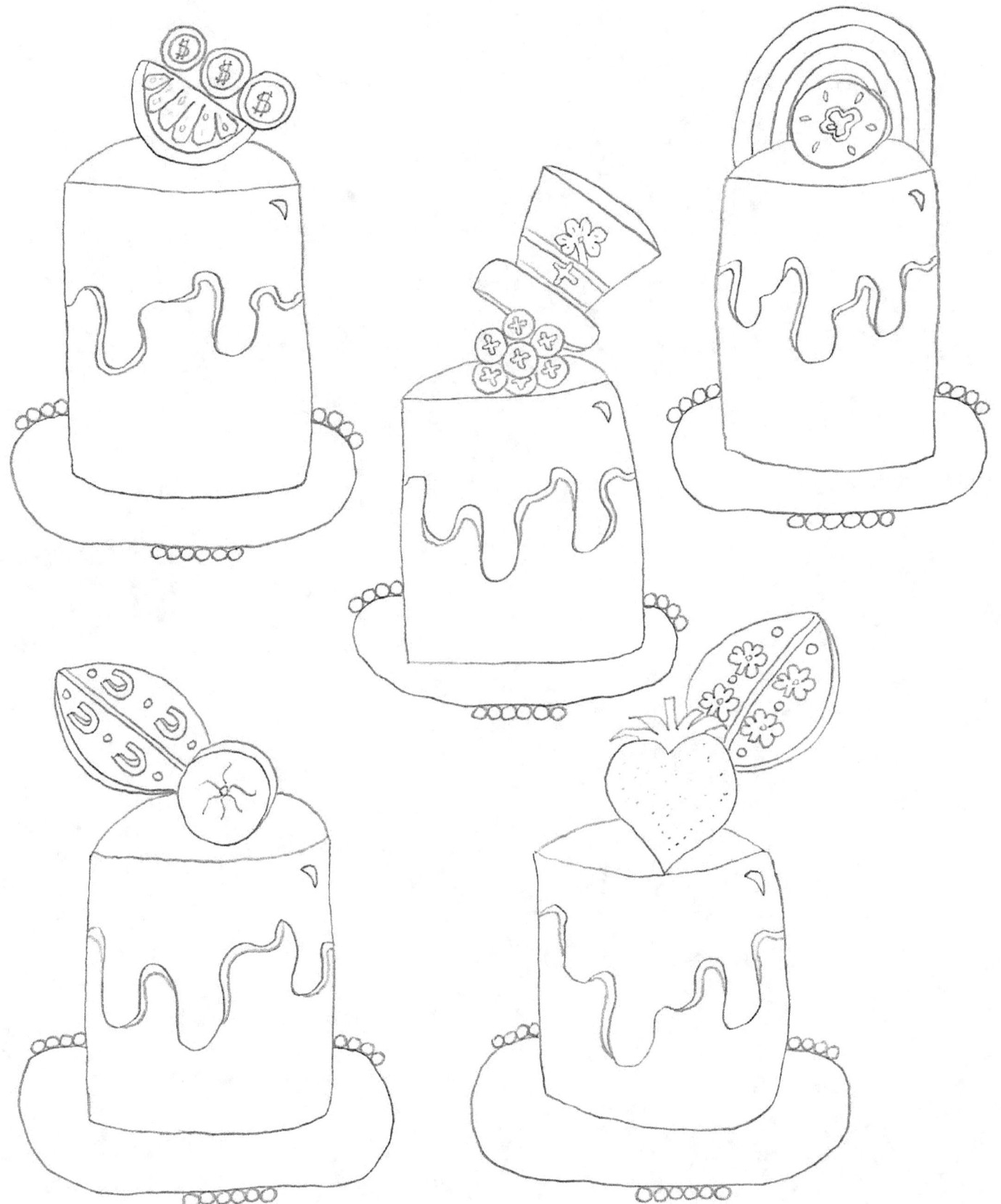

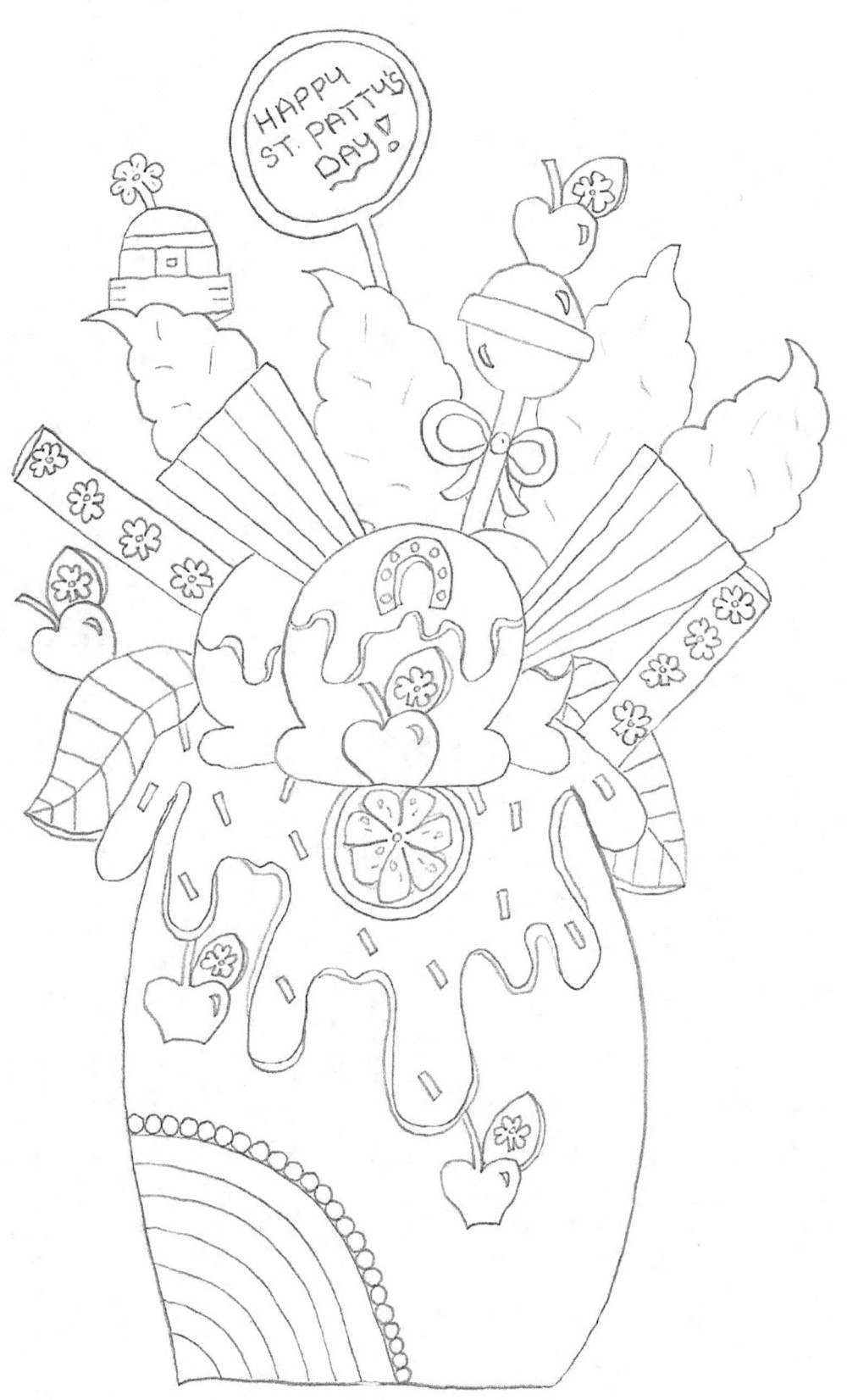

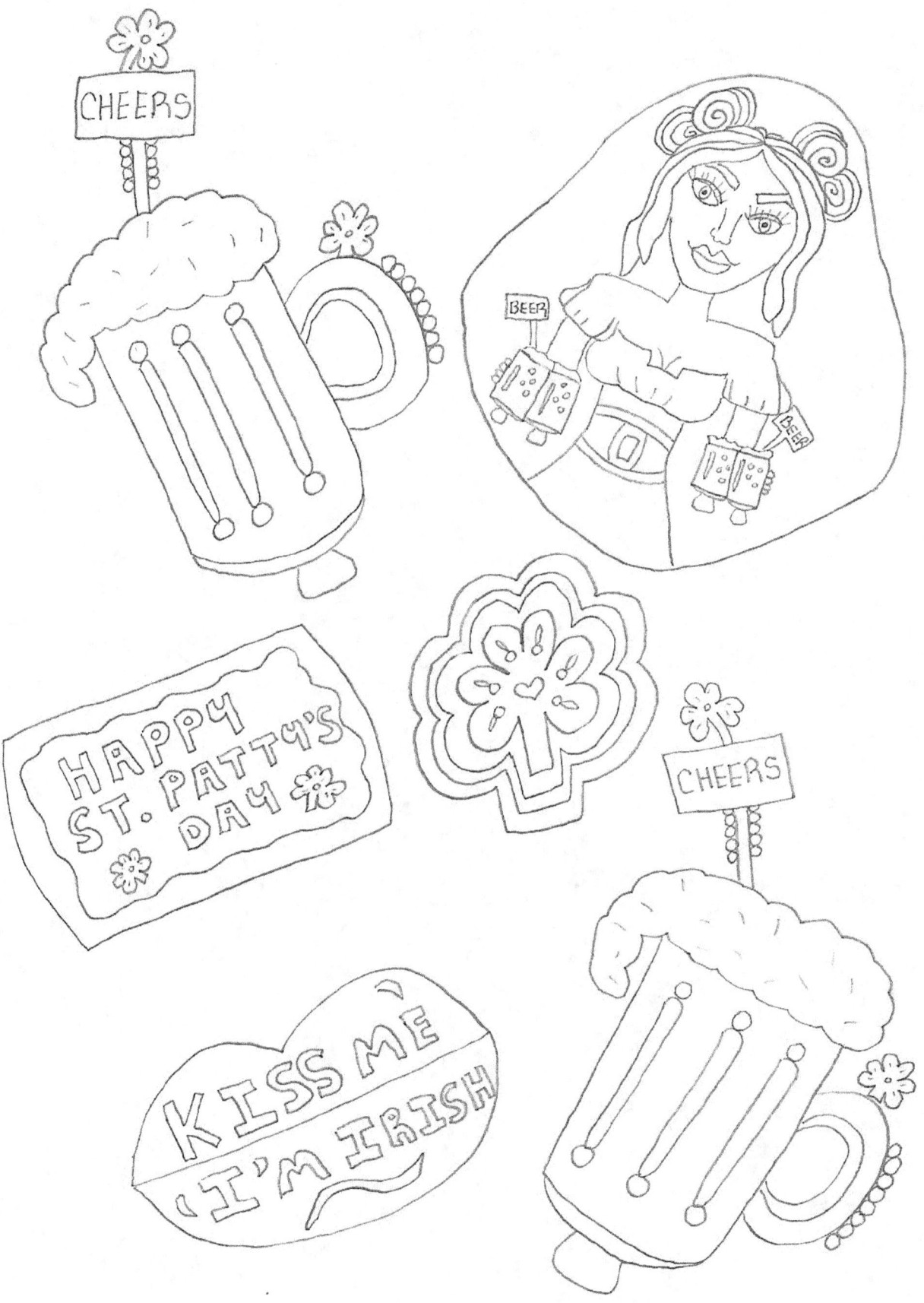

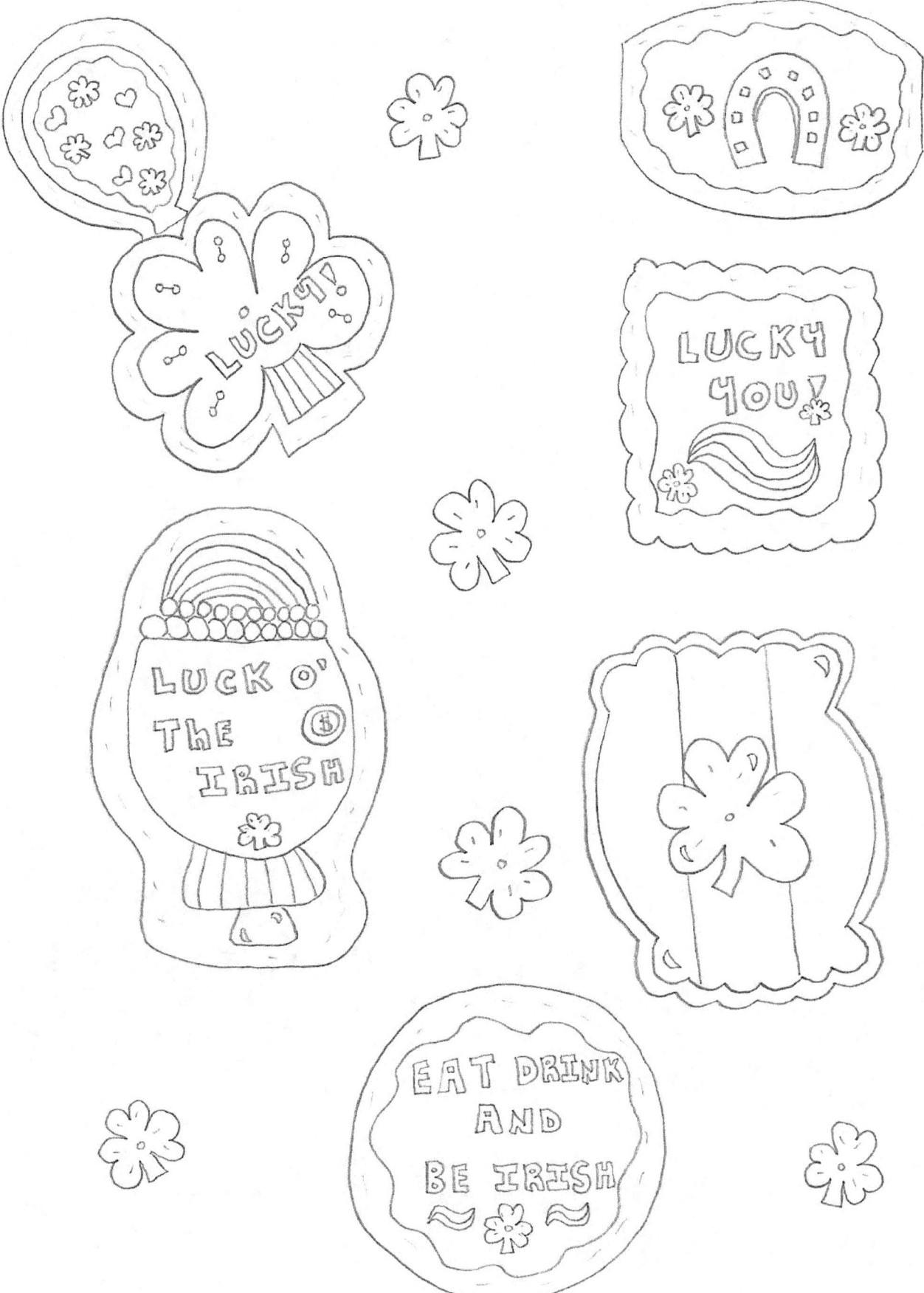

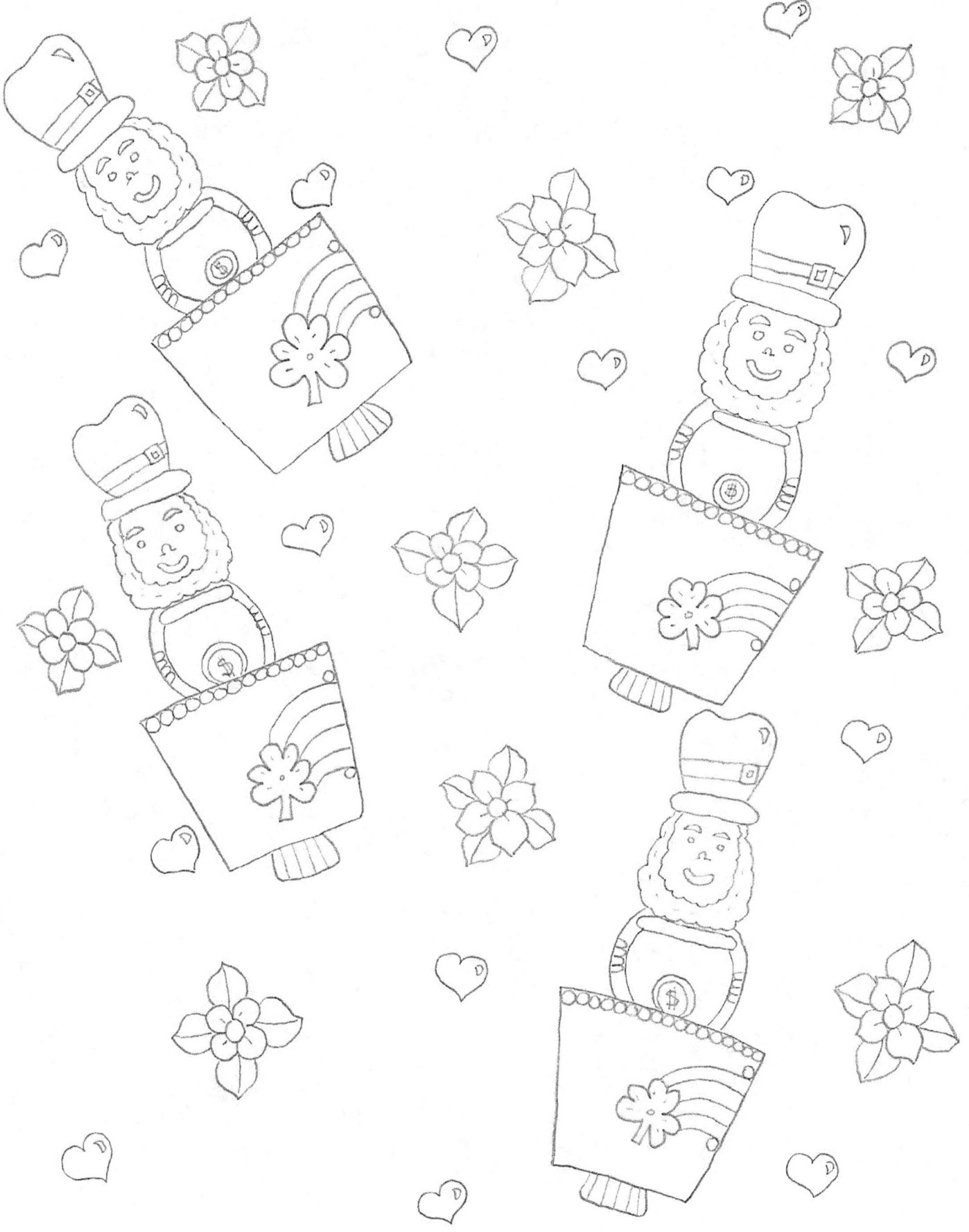

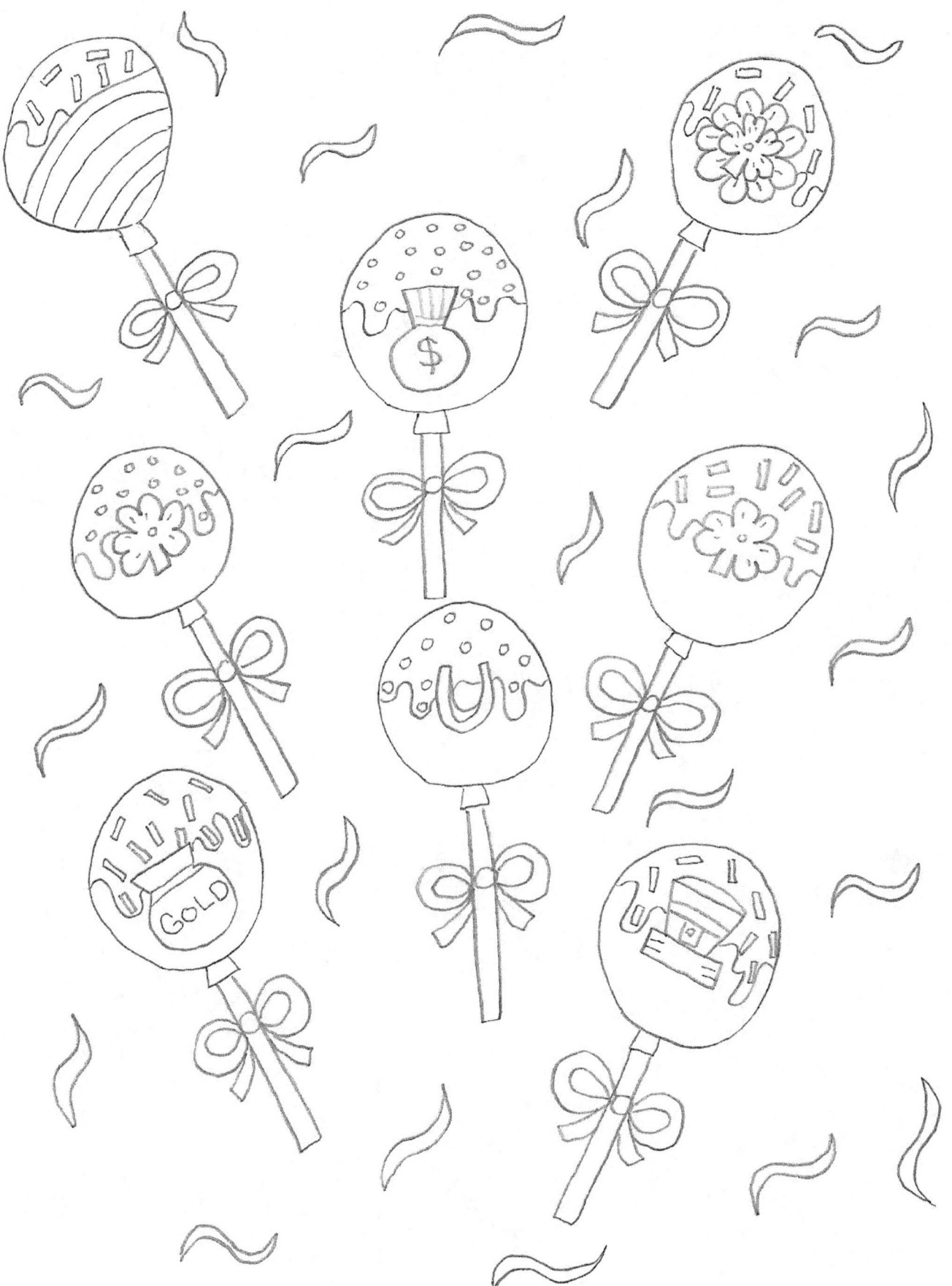

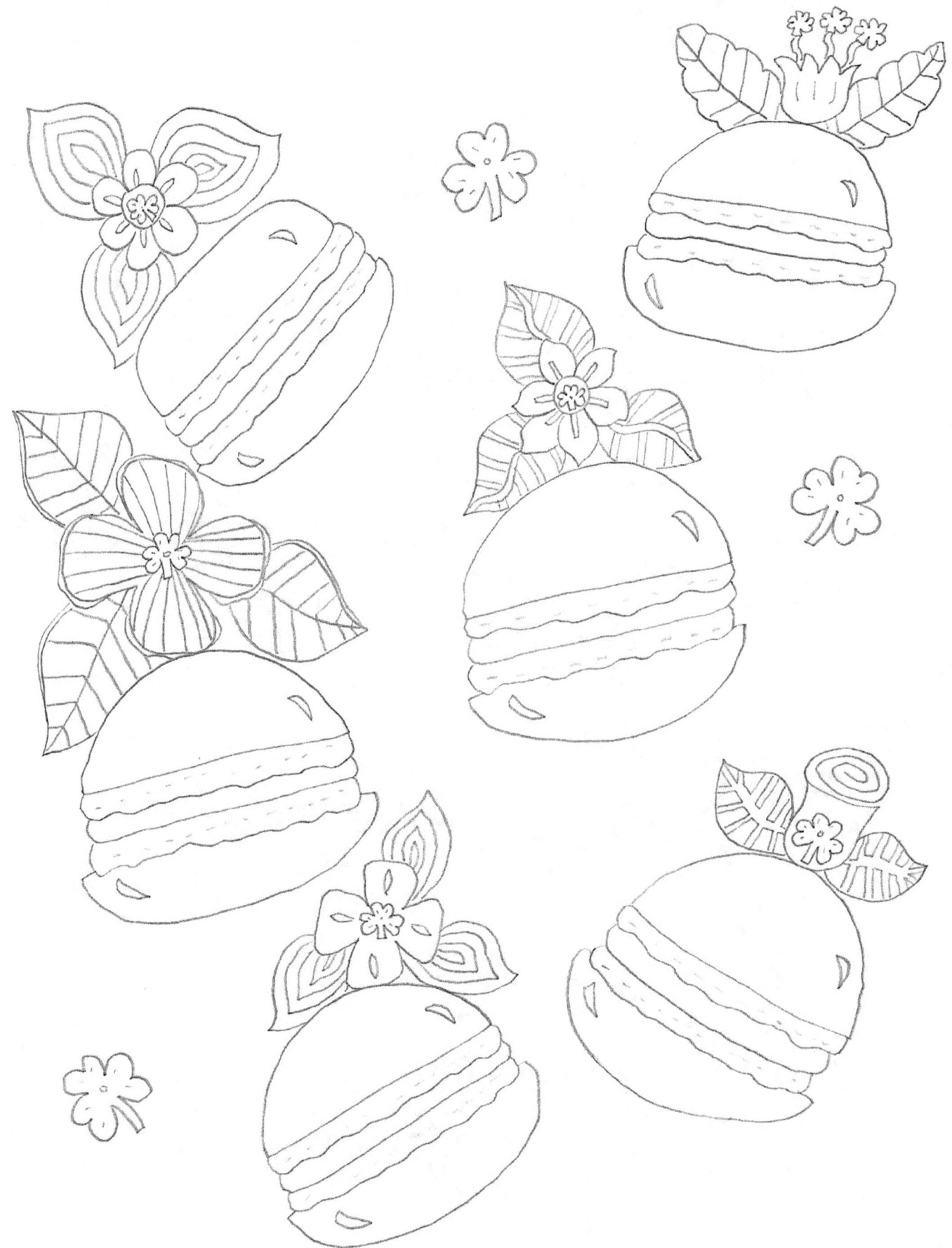

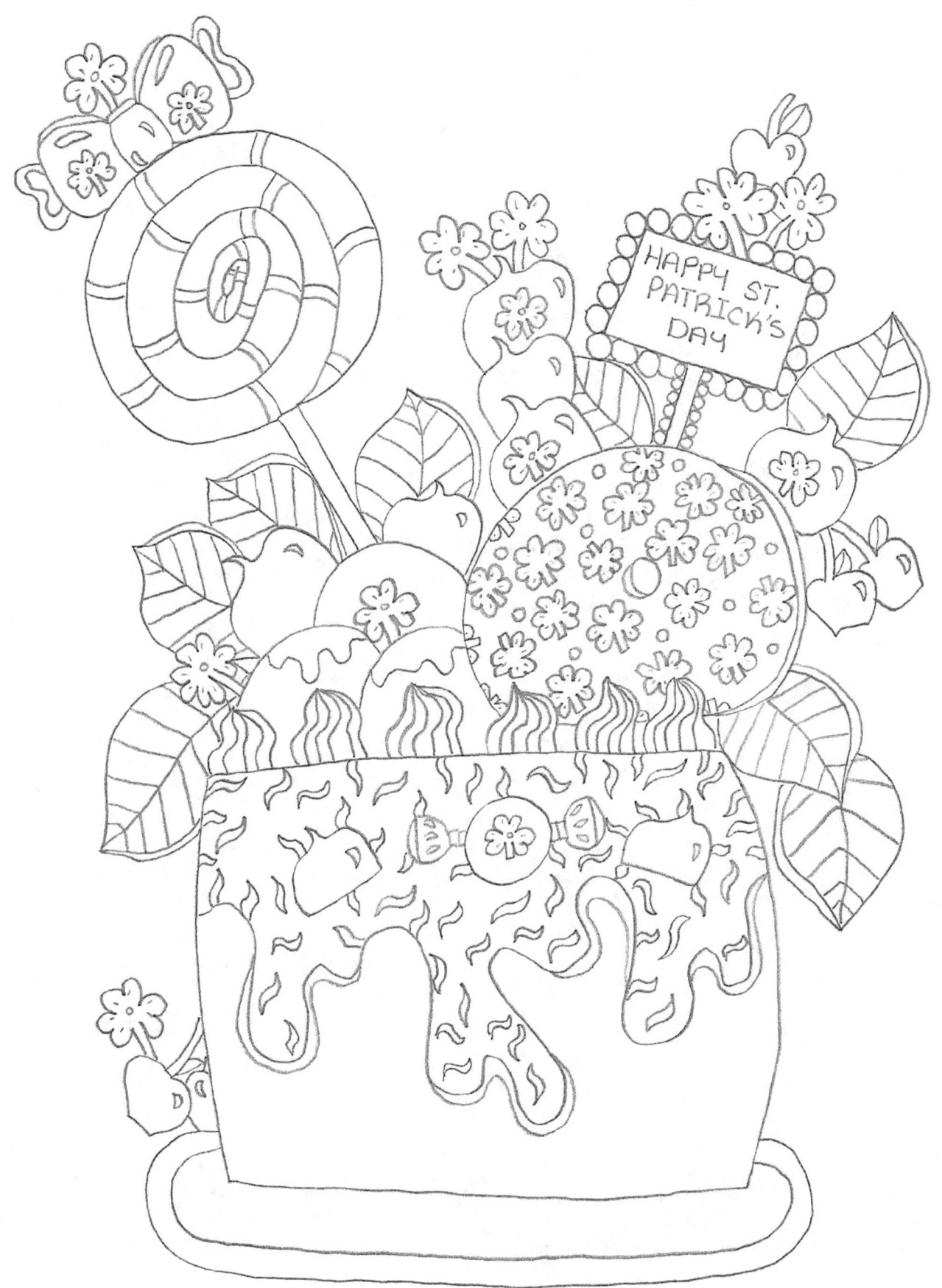

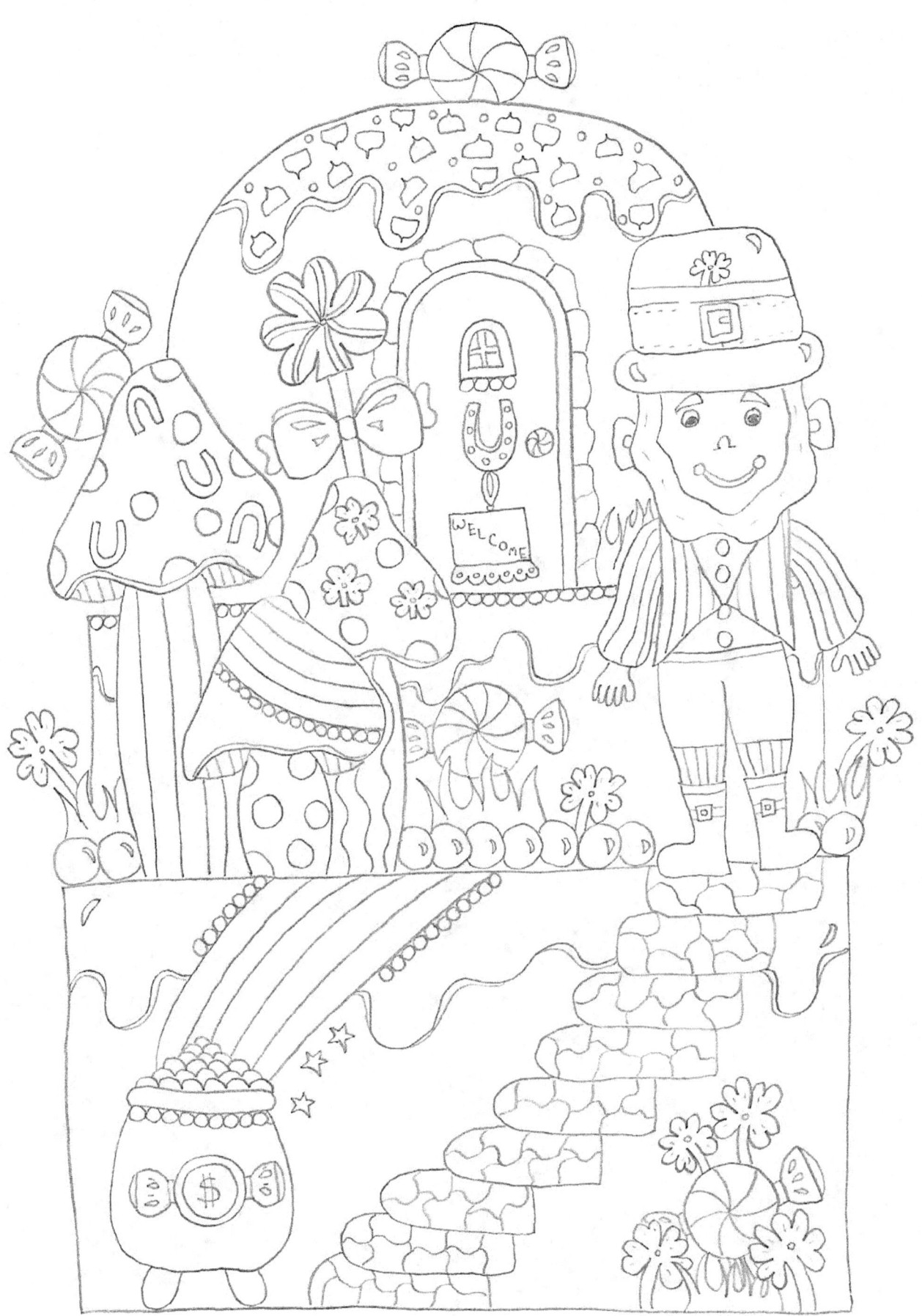

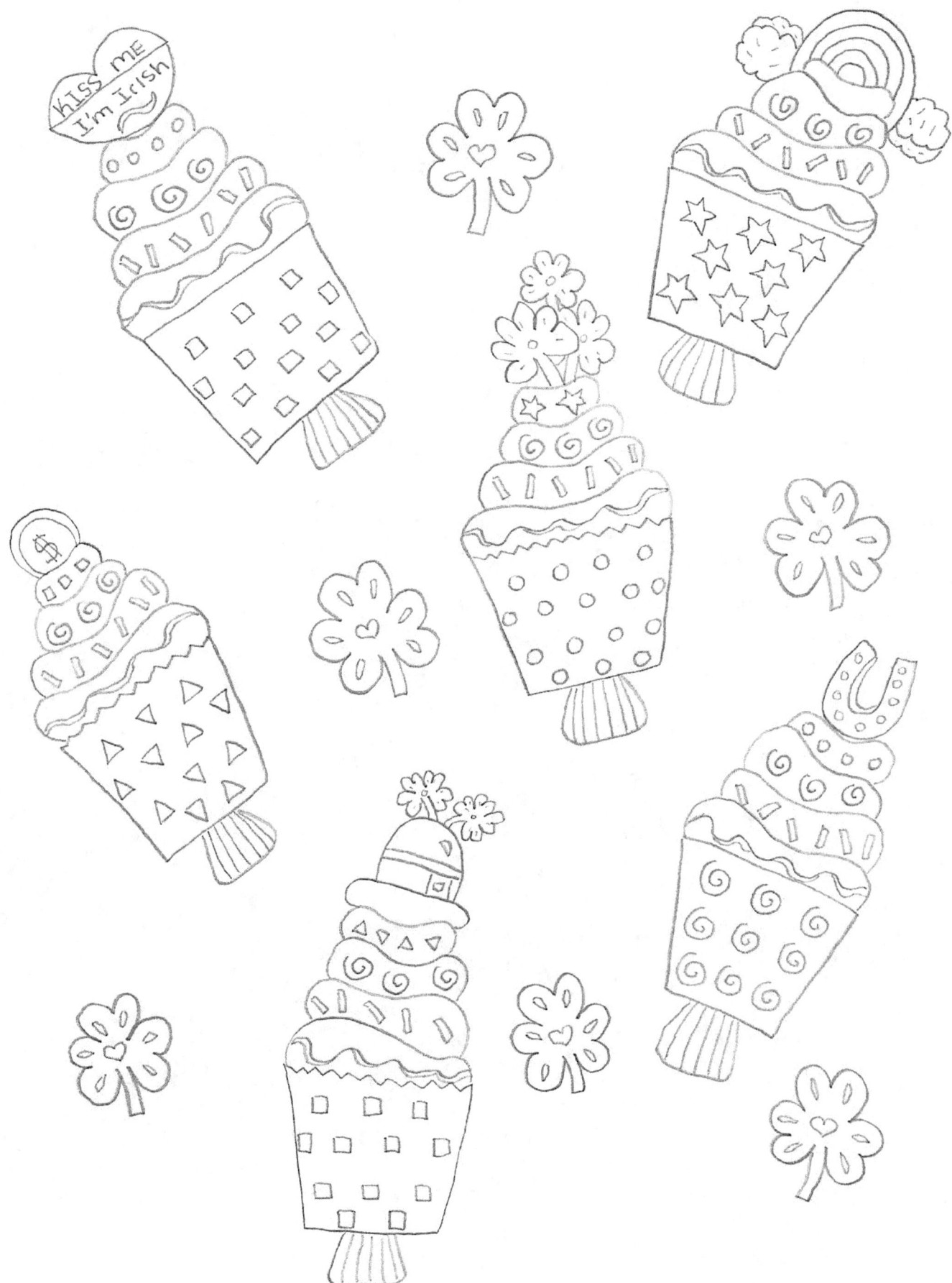

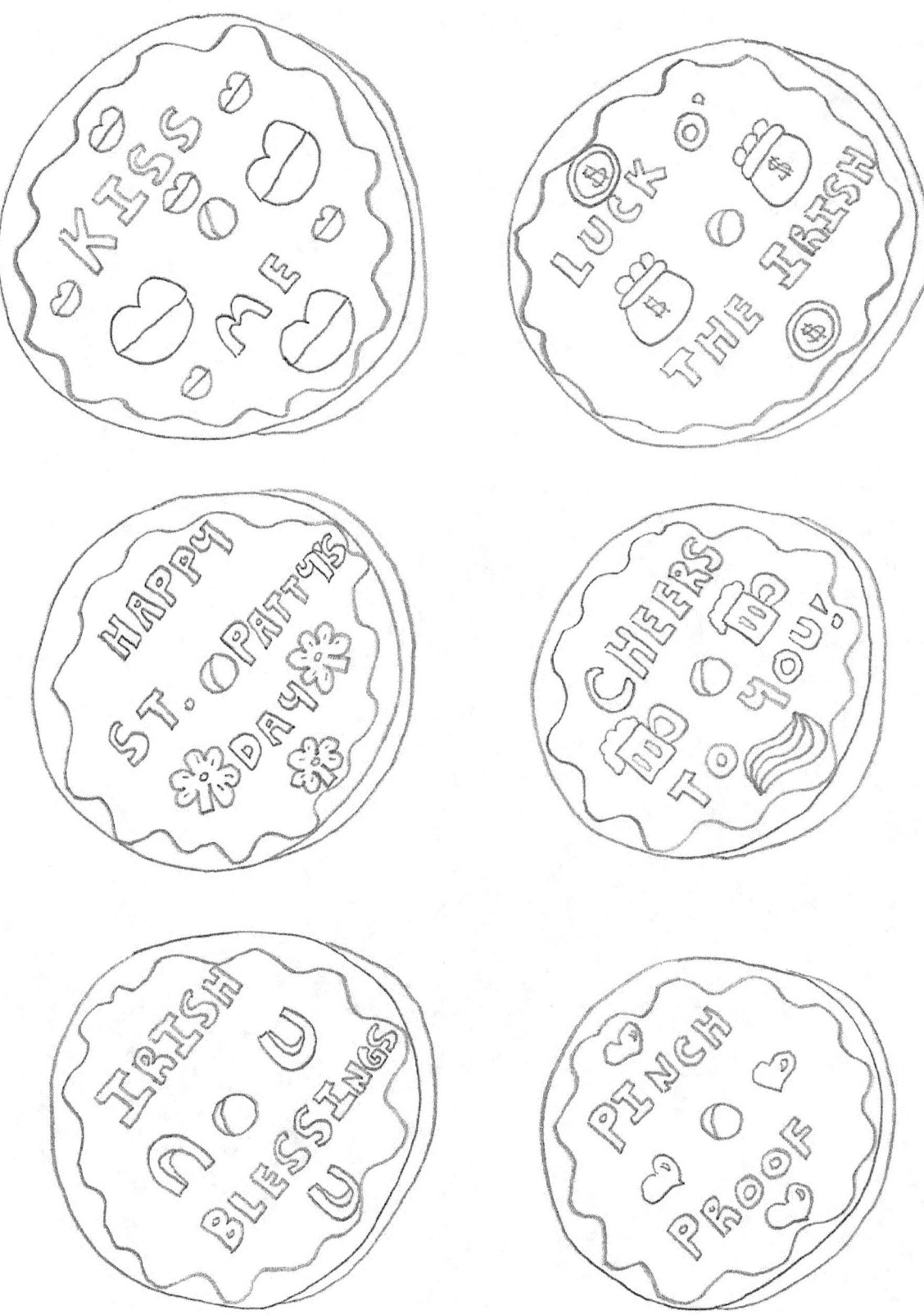

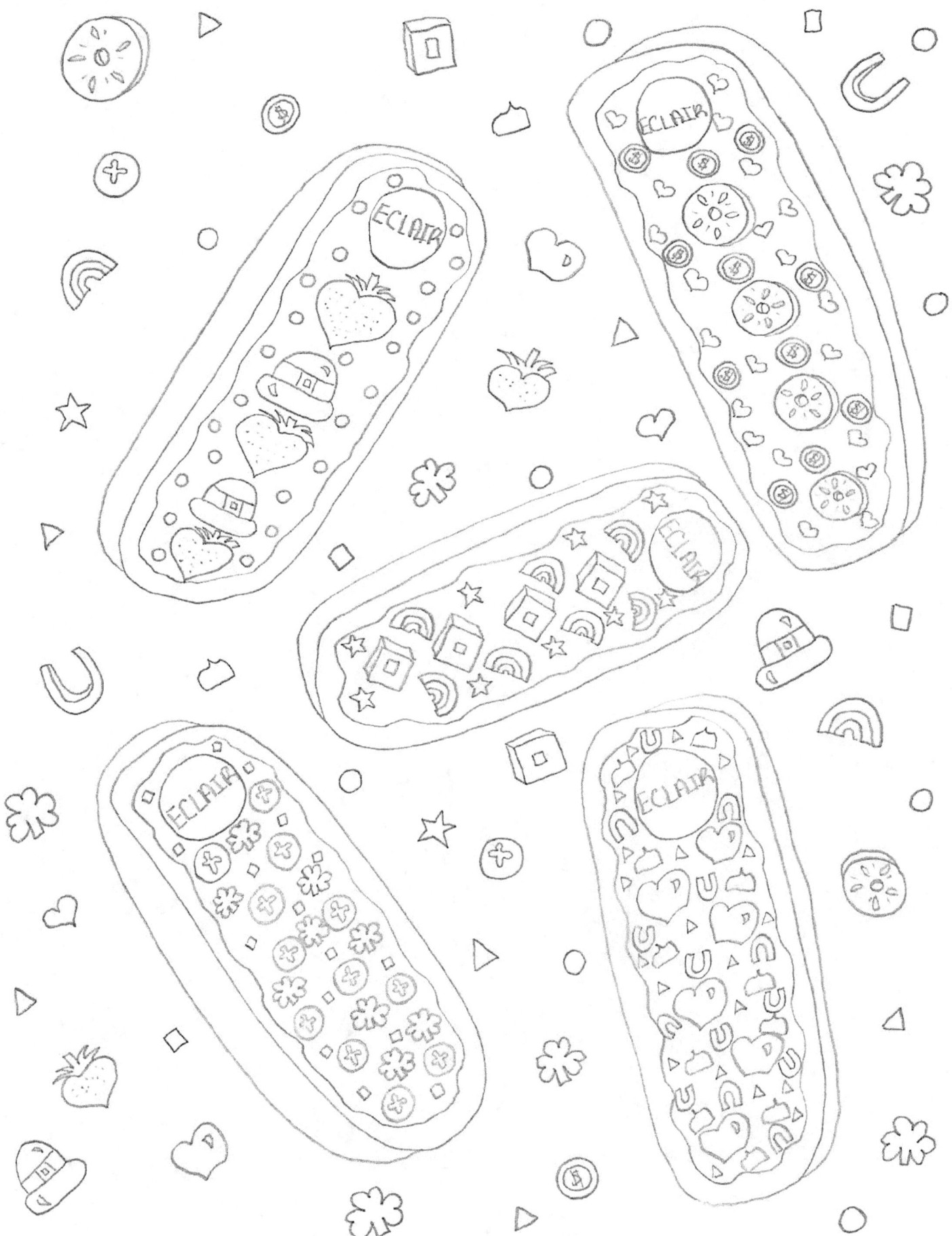

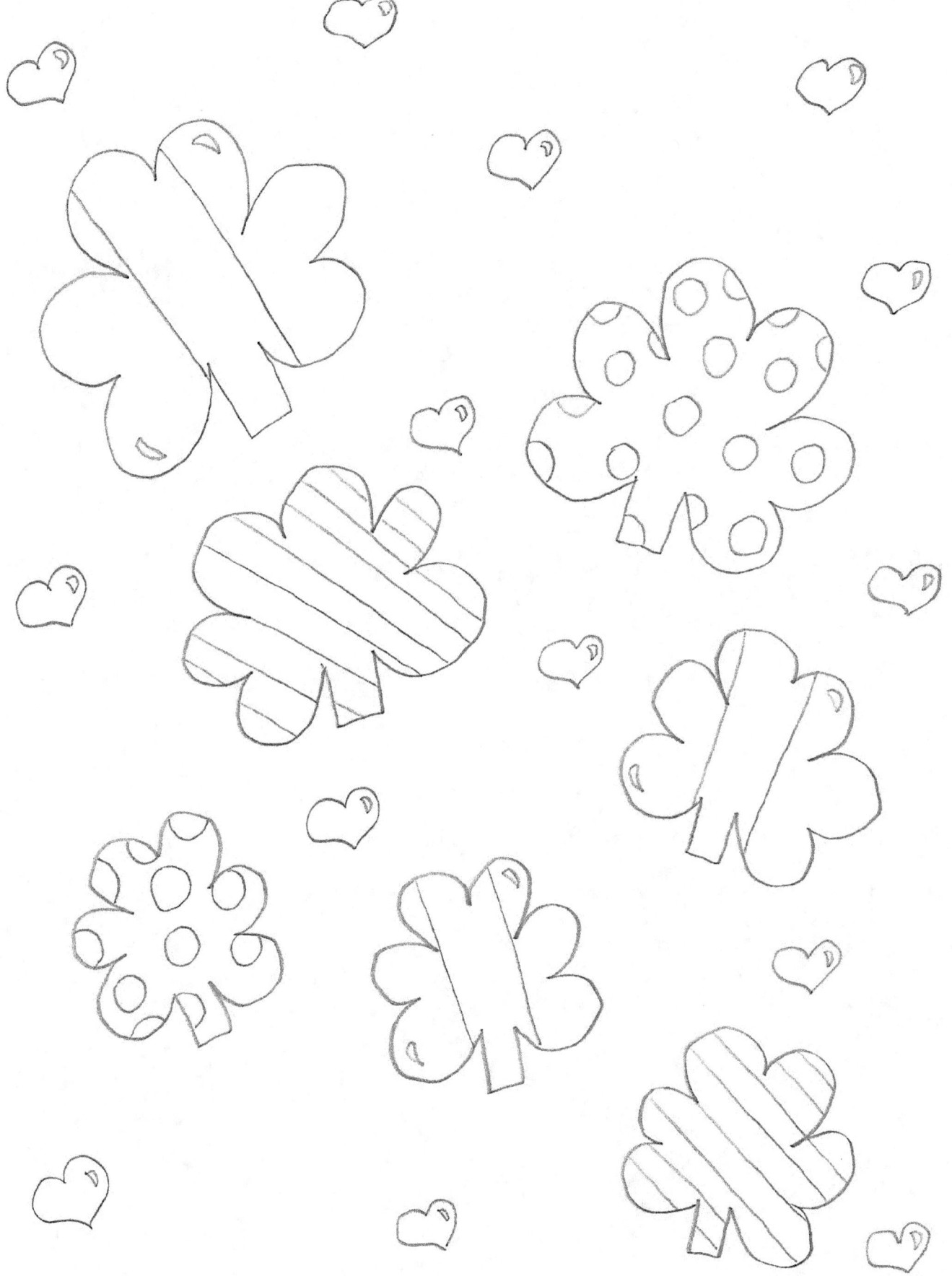

THANK YOU FOR PURCHASING ST. PATRICK'S DAY DESSERTS ADULT COLORING BOOK. YOU CAN CHECK OUT MY OTHER COLORING BOOKS LISTED BELOW WHICH CAN BE PURCHASED AT AMAZON.COM:

VINTAGE PARIS BAKE SHOP (Adult)
VINTAGE WINE GARDEN (Adult)
ICE CREAM MADNESS (Adult)
ICE CREAM MADNESS VOLUME 2 (Adult)
TEA & COFFEE TROPICAL TREASURES (Adult)
TEA & COFFEE OCEAN TREASURES (Adult)
TEA & COFFEE TREASURES (Adult)
BOTANICAL FLOWERS & MANDALAS (Adult)
MAJESTIC FALL (Adult)
A VERY RETRO CHRISTMAS (Adult)
MAGICAL DESSERTS (Kids)
MAGICAL DESSERTS VOLUME 2 (Kids)
MAGICAL DESSERTS VOLUME 3 (Kids)
FASHION DOLLS (Adult)
FAIRIES IN THE FLOWER GARDEN (Adult)
MERMAID'S WONDERLAND SEA OF ENCHANTMENT (Adult)
CHRISTMAS DESSERTS
VALENTINE'S DAYDREAMS COLORING BOOK (Adult)
VALENTINE'S DAY DELIGHTS (Adult)
VALENTINE'S FLOWERS & DESSERTS (Adult)
VALENTINE'S DAY DESSERTS (Adult)
VALENTINE'S DAY ANIMALS & Sweets (Kids)
VALENTINE DAY'S FLOWERS (Adult)
A VERY RUSTIC VALENTINE'S DAY (Adult)
ELEGANT FLOWERS (Adult)
ST. PATRICK'S DAY BLESSINGS (Adult)
A HAPPY ST. PATTY'S DAY (Kids)

IF YOU ENJOYED YOUR COLORING EXPERIENCE, PLEASE TELL OTHERS ABOUT IT BY WRITING A REVIEW ON AMAZON.COM UNDER THE BOOK YOU COLORED.

www.ingramcontent.com/pod-product-compliance
Lightning Source LLC
Chambersburg PA
CBHW081638220526
45468CB00009B/2485